Lost and

KUHL HOUSE POETS
edited by Mark Levine

LOST AND

by Jeff Griffin

University of Iowa Press, Iowa City

University of Iowa Press, Iowa City 52242
Copyright © 2013 by Jeff Griffin
www.uiowapress.org
Printed in the United States of America

Design by Kristina Kachele Design, llc

The University of Iowa Press is a member of Green Press Initiative and is committed to preserving natural resources.

Printed on acid-free paper

LCCN: 2013934855
ISBN-13: 978-1-60938-199-8
ISBN-10: 1-60938-199-8

To Janet and Steve Griffin

CONTENTS

ACKNOWLEDGMENTS

Special thanks to Janet Griffin, Steve Griffin, Ron Griffin, Bryan Moss, Jason E. Smith, Mark Levine, and James Galvin.

Some of these pieces have been previously published, sometimes in slightly different form, in the journals *Milk Money* and *The Destroyer* and in the chapbook *There's Never Been a Day That Didn't Require Knives Like These* (Iowa City: Human 500).

PREFACE

The following work I found discarded at various locations around the desert, mostly in abandoned trailers and homesteads, from 2010 to 2013. The pieces are either transcribed verbatim or scanned as is.

I. BRISBANE VALLEY, CALIFORNIA

Notebook dating to the 1950s that details a budgie's linguistic development.

A

WORDS PHRASES AND SENTENCES

a
at
aren't

B

baby	
Barbara	Where's Barbara? Where's big Barbara?
beer	Where's the beer, Barbara
big	Look at the big, big, big bird!
bird	See the bird
birdie	big birdie
boy	pretty boy
Budgie	
bad	He's a bad budgie
break	break the hawk!
bank	
bell	ring the bell
bite	Let's bite!
brat	you little brat!
Billy	Give me a kiss Billy Boy!
Butch	Where's Barbra's Butch bird?
butcher	from butcher bird

C

Come come on, come on!
cute

D–E

doin' What chow doin' big birdie?
dear Big, dear Barbara or Brarbra
dirty Dirty Pancho
don't why don't you—
dearie
doggie
drink drink it—drink it!

everybody

F

G

go	Let's go!
great	great big bird
get	Let's get up
good	good budgie
gonna	gonna kiss the little bird
Gallahad	Sir Gallahad

H

how	how sweet the bird!
he's	he's a bad budgie
happy	happy bird
here	come here
hot	it's hot!
honey	Come on, honey.

I

I'm
it's hot!

J

just

K

kiss	kiss me, kiss the little bird!
know	don't you know—
keep	gonna keep Butch
Kitty	

L

let's	Let's go
little	
leetle	
look	look at the big bird
love	don't you love me?

M

my	That's my big bird
matter	What's the matter?
Marge	Sweet Marge
me	Tell me a story

N

no oh, no you don't!

O

on
out watch out
oh oh dear!

P–Q

pretty	pretty boy
Pancho	Dirty pancho
people	See the people (looking out window)
Peaches	Where's peaches?
please	please talk!

R

rascal	I'm a rascal.
real	real big budgie
ring	ring the bell

S

sweet	sweet bird
such	such a big bird
sweetheart	
see	see the bird
sleepy	Sleepy bird
Sir	
smart	you're smart
sugar	
said	"—said the big bird!"
she	she loves me
silly	silly bird
supposed	You aren't supposed to—
story	Tell me a story

T–U–V

that's	that's my big bird
the	
talk	let's talk—please talk!
two	two, two
three	
up	Let's get up
uh-huh	
tell	Tell me a story

W–X

what	what you doin'?
where's	
whysky	Where's the whysky Delbert?
well	
watch	Watch out
why	why don't you
we	here we go
wonder	wonder what you
water	

Y–Z

you	why don't 'chow—
you're	you're smart
yes	Yes, little bird

THE STORY OF MY BUDGIE
BUDGIE MEMO

When our little feathered darling ran into his green glass and said "Del-b-e-r-t."

Another time he stuck his head in, standing on the rim of his glass, leaned way over and cried, "oh boy!"

One nite he surprised me when he said, "Wh-e-r-e's big Barbara?" He spent all the next day with phrases such as "Where's Barbara? —Where's the whysky, Delbert?" —and made a gramatical error, "Where's the beer Brarbra?" "Come on, come on!"

One day when Sir Gallahad was a year and a couple months old I had him on my shoulder by the kitchen window when a little humming bird came over to the window sniffling at the fuschia plant. I talked to Sir Gallahad about the little humming bird and said "See the little bird?" Then I turned to the stove and he piped up, "Yeah, see the little bird, honey?"

Another little incident was when it was about 8:30 P.M. and Sir Gallahad was a half hour past his bed time. He had been kind of dozing on his gym but at 8:30 he began his constant calling for someone to come to him. Every little chip was the rhythm of "Come put me to bed," so I went and opened up his cage door and in he hopped. The smart little guy was so-o-o sleepy, he'd had a busy day.

When we first got Butch, our cockateel, Sir Gallahad was afraid of him and would just sit on top of the cage and say, "Butchie," or "Butch," and from then on all he talked about was Butch, "See the little Butch bird," "kiss little Butch," etc., "Butch, Butch, Butch."

In a couple days Sir Gallahad was imitating anything Butch did. He would sit in the cockateel cage and talk, where every thing is giant size to him, and if not able to reach the drinker or seed cups he climbs upon them. He always chews on Butch's tail and tries to use it for a swing.

When Sir Gallahad sees Butch cracking sun flower seeds he must have some too although his little beak isn't strong enough to break the husks open, he tries anyway. They also eat seed together from Sir Gallahad's little feeder on his play ground.

Butch likes to pick up tooth picks and turn them in his beak, but when Sir Gallahad tried it it didn't work. He kept dropping it.

II. EAST OF TWENTYNINE PALMS, CALIFORNIA

Chapman is my shepherd; I shall not think.

HE maketh me to assume the position with my socks off;

HE leadeth me beside my locker;

HE restorath my faith in bolt cutters.

He leadeth me in the paths of paranoia for HIS ego's sake.

Yeah, though I walk through the gates of Corporate Security,

I still fear THY evil; for THOU still work here:

THY rod and THY staff they intimidate me.

THOU preparest a false cause against me

in the absence of my accusers:

THOU anointeth my reputation with unfounded accusations

and cup runneth over with indignation.

Surely deception and illegalities

will follow me all the days of my life

and I will dwell in the house of self-righteous fascism

forever.

My husband has a problem controlling his anger. He will "blow up" at the smallest things. It is difficult on the entire family. I get especially upset when he fails to control his anger around our children. On many occasions he has thrown and broken things. Once he threw a plate over our older daughter's head and it struck the wall and shattered, almost hitting her. Another time he threw a pop can at Madison's head. When my husband acts out his anger it really upsets the children. Ryan will sometimes yell at his dad asking him to stop. Peighton screams really loud or cries when Jari has fits of anger. She gets the most upset of all the children. Madison is autistic and doesn't seem to understand what is going on a lot of the time, but once in awhile she will act really nervous and start to cry. On a couple of occasions when Jari is yelling at me, Jari has banged his head repeatedly against the door jamb and punched himself on his head. On another occasion he repeatedly banged his head on the tile countertop in the master bathroom. On this last occasion Peighton came into the room and saw Jari's head bleeding as a result of his head banging.

Alcohol, drug and sleep deprivation issues: Jari drinks beer almost every day. He also takes some form of speed or prescription drug such as ephedra to keep himself awake after he has worked his late night shift. Jari works the graveyard shift at his employer and has done so for years. He has turned down promotions because he does not want to work day shifts. When he has changed jobs, he has specifically looked for jobs where he could work nights. When we bought our current house a year ago, Jari wanted to keep working nights so he could care for our girls during the day while I am working and we would not have to pay for child care. The problem with this arrangement is that he rarely gets more than a few hours of broken sleep each day.

This seems to add to his behavioral problems, and the use of the alcohol and speed has also added to our marital and parenting problems.

Marital breakdown: The marriage really broke down last summer. We were fighting almost constantly. In September 2003 I met a man by the name of Nick, with whom I had a romantic relationship until the end of November 2003, when it ended. My husband found out about the relationship on November 25, 2003. At that time he threatened Nick at a restaurant where Nick worked and harassed him. I suggested Jari and I go to counseling which he refused to do initially. We finally attended 4 or 5 sessions but stopped going because it was not helping, and it is plain the marriage is over.

Recent events: Two weeks ago Jari called me at work and told me he was going to kill me if I didn't stop lying to him about my relationship with Nick

Dear Nick,

I know you're mad at me and probably don't care what I have to say. But I hope you'll at least take a few minutes to read this letter.

I know I've already said it but I sincerely am sorry for what I did. I didn't call Meredith to hurt you or get back at you for anything. I was way too drunk for my own good and I was also very hurt by the way you were treating me. That wasn't fair at all. I didn't do anything to deserve that. I have been nothing but nice to you. And don't tell me that you've haven't done anything stupid while you were drunk.

I am sorry that I met you when I did. But we can't turn back time. I think that under different circumstances things would have turned out much different. I have never been too much about sex. I thought it would be fun to try something new with you. Honestly I would have been happy keep you as a friend. But for some reason I just didn't think you'd be interested in me for just that. So I figured I needed to do something to spice things up a little bit. And you know what? It worked.

You were right about me not being totally happy with myself. How could I be in my situation? I've been in a relationship for almost 9 years, 6 of them being bad. My husband was never hurtful towards me for the way I looked or anything like that. In fact he was the complete opposite. But I felt bad about myself for putting up with all his shit all those years. I didn't ever feel strong to just leave and yet

Just because I was seeing you behind my husband's back doesn't mean that I don't care about my kids. You really hurt me when you said that. They know nothing and I always made sure they were ok before I left. I am always trying to protect them from anything that

might hurt them. All I can say is that you wouldn't understand unless you were in my shoes. I know it was still wrong for me to be with you, but for once in 6 years I actually had something in my life that made me really happy, besides my kids of course. Something I never thought I would feel again. The excitement you brought to my life was great. You made me actually care about myself again and made me realize that when I leave I'm going to be ok. And someone will someday care about me again. So no matter how wrong this was it still wasn't for nothing. I am so glad to have had that with you. But like

I didn't get a chance to show you the real me. I think because of my situation you were very guarded. Because of that I stayed somewhat reserved. I felt like there were so many things about my life that I never got to share with you. In a way I felt like you would talk about yourself and not ask me anything just to keep from getting too close. I don't blame you for that. I completely understand. It's just something that I've never experienced before so it was difficult for me to deal with. I wanted so bad to get close to you.

I know this is getting really long so I'll try to cut myself off in a minute.

One thing I really want you to understand is that I truly did care about you so much more than you know. I still do. Even though you kept things from me that you shouldn't have. I am really hurt by what you did, but I have already started to forgive you. I know you're just at that point in your life where you're trying to get things figured out and there is so much you want to accomplish in order for you to be happy. I would love to be friends with you again. I mean it when I say that. Just friends. If you can't ever find it in your heart to forgive me that's ok. You need to do what makes you happy. But I really do think we could be good friends.

I hope that someday you find true happiness within yourself. But please, for yourself, figure out what it is that you want before you get yourself involved in another situation like this. No one wins. Three of us got in this and that didn't need to happen.

Ok, just one last thing before I go. I want you to know one more time that I'm sorry and that I miss you already. I'll think about you every day for a long time.

Take care,
Lori

P.S. I wasn't planning on not seeing you again so I borrowed your sweatshirt when I left Saturday night. I woke up and was really cold so I put it on. If you want it back let me know where/when I can drop it off. I would drop it at your apartment when you're not there but I can't get in the building.

he has no place to live now when he turns eighteen and the foster care industry formally and officially abandons him for good.

So a military airforce recruiter shows up at the high school and makes him feel real good, real excited, pictures himself in a military uniform, gives him the big "build-up" about traveling to distant lands, flying a jet etc. and this is probably the first time he felt a man talking to him and showing some genuine concern since Jimmy Curran, Walter Irish, Jeanete Agilpay, Donna Gordon, , ARMANDO CORELLO STUCK THEIR GODDAM FEET IN OUR FRONT DOOR AND TOOK OVER HIS LIFE.

WITH DEEP AND ABIDING HATRED FOR ALL THE ABOVE MENTIONED NAMES, YOUR SINCERELY DEVOTED ENEMY FOREVER,

I never got to do ~~want~~ what
I want to do every-body gets
to do what they want to do
but me.

cose you would ge
mad at at me, wouldnt
you, maybe we cald do
a three som, that way
we both have
him. WB

PARTY

Joy,
Your Invited to
a Party, Housted by:
Heather and Bethany.
When - 10/10/02
where - Motel Room 52.
Why - For Fun military
how - anyway. Housing
Kihel - Sex party.

COME Best
 Ever

37

Paige
mateehi
1-106'
1-10
16-30
math
171

1 3
2 3
3 3
4 2
5 3
6 3
7 6
8 4
9 4
10 3
16 90
17 20
18 70
19 80
20 50
21 500
22 300
23 600
24 ...

Hey I did not tell
you at I have a two
year old boy Named AarronKenny
LennyDepp. his dad is Amryboy
Aarron going to be with his dad
for the summer. his dad lives in
San Antonio, TX. I will be
leving to Tx soom. I'm Moving
to Rarner, Arizonea by 6th
I will Miss you I hope we
still see echother. Well I tolled
you about my son wow and others
Stuff well I got to go Now bye
bye I really really Like you

xo

Bethany

P.S e-mail me.

@ yahoo.com
do you have
a e-mail if
do please tell
me!

26
27
28
29
30

Once-a-day
Lēvaquin™ Injection
(levofloxacin injection)

Cory,

You need to call me I need to
talk to you bad... why did you lie
to me. I talked to Katie and she
said you were not going out
with you in the car... she I
don't know why I'm going out with
that dumb bitch anyway. She
If you were really going out with

08R2268

Page 1 of 2

May 20, 200

I am sorry for all the things that I have done to you and others but there will be no more of that. I will be gone for good orwnly remenise ofme no more blaming thing on me. well bye Danielle, Erick, Fian, bethany, Nance, Ray, Genevia, the woods, theroots, keen, B.F. Bye to Andrew.R. I Love you. well nood Bye I.s god.
a

Matt. R
March 4, 2002
Frist Time have sex

III. LUCERNE VALLEY, CALIFORNIA

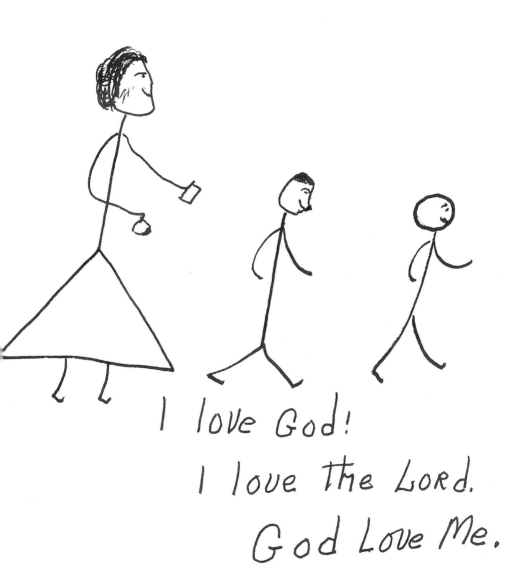

I love God!
I love the Lord.
God Love Me.

IS IT RIGHT OR WRONG?

Moral Issue	Society, the ▓▓ says: (Bias #1)	My friends say: (Bias #2)	God, through the Bible, says: (Conviction)	My own feeling is: (Opinion)
1. Premarital Sex	~~wrong~~ ~~right~~	~~right~~ ~~wrong~~	wrong	wrong
2. ~~drugs~~	~~wrong~~ ~~right~~	~~wrong~~	~~wrong~~	~~wrong~~
3. Greed	wrong	right	wrong	wrong
4. Bad Language	right ~~wrong~~	right	wrong	wrong
5. Drinking	right ~~wrong~~	right	wrong	wrong
6. White Lies	right ~~wrong~~	right	wrong	wrong?
7. Stealing	wrong	~~right~~ wrong	wrong	wrong
8. ~~disrespect~~ Disobedience	right	right	right	right
9. Homosexuality	wrong	wrong	wrong	wrong
10. Gossip	right ~~wrong~~	right	wrong	wrong

James

Romans 12:2
 Self gratification
Just ask God
 Bible has laws
when in doubt, ask

The Importance of Understanding Sex

	Agree	Disagree

Agree-Disagree

1. The number <u>one</u> reason for sex is to have Children. — ✓

2. Sex helps you understand how you really feel about the person you are dating. — ✓

3. Sexual intercourse is O.K. if the two of you plan on marriage. — ✓

4. Sex will help you find out if you are compatible — —

5. Day dreaming about sexual intercourse is not healthy. — ✓

6. Sex is sin — ✓

7. Sex is a physical need that we all have. — —

1. Why does sex have such a great influence in our life? _____

A. List some songs on the radio that speak of sexual activity

 1. _____

 2. _____

 3. _____

B. List some movies or TV programs where sexual suggestions were made.

 1. _A Case of Rope_

 2. _Hustle_

 3. _Hotel Baltimore_

C. List some advertizer's attempts to manipulate your sex drives with products such as

 1. Shaving cream

 2. car lots

 3. _____

 4. _____

 5. _____

 6. _____

 7. _____

"SEX"

I. Sex is a gift.

 A. Given by God

 B. "Giver" Designed Guidelines

 C. Powerful Force

II. Sex is more than a physical act.

 A. Total Union

 B. Takes Practice

 C. Turns like to disgust

III. Pilot Lace

1. STATE to the court how long you have known the Def...

2. ... your relationship with the Def.?

3. WHERE WERE you the EVENING of the 5th of Nov.?

4. Did you witness an exchange of money between the Def. and Antones?

5. Who was that person?

6. Do you recall how much?

7. Do you happen to recall what it was for?

8. On the night of the 6th of Nov were you with the Def.?

9. WHERE WERE you going?

10. How long WERE you to be gone?

11. Who else was present?

MANAGER — OWNER

9:05 I, CALLED BACK SO THAT
I'D BRING PAYMENT OF $105.
OVER, SAID SHE HAD TO
LEAVE. ~~S~~ I SAID I'D BE
RIGHT OVER — WENT OVER
BUT NO ONE ANSWER — ALTHOUG
SOMEONE LOOK FROM BEHIND
CURTAIN, PRISON GATE WAS

50

Roger Nerguser ▮ friend of Tom's

Call jail — say something is happening

office — 714-898 0984 -

IV. BARSTOW-YERMO, CALIFORNIA

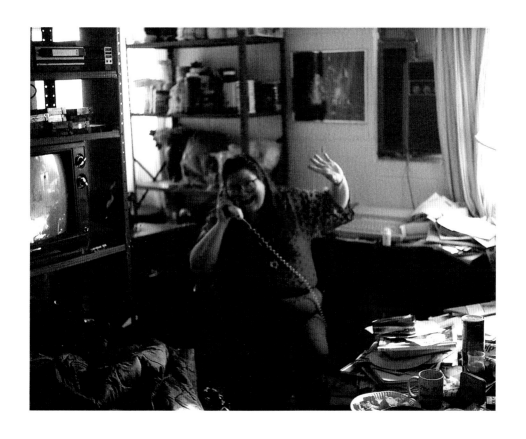

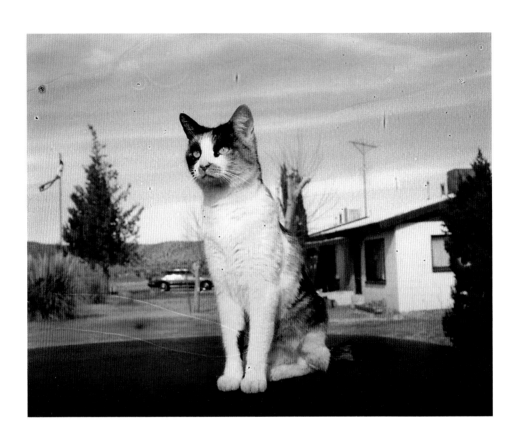

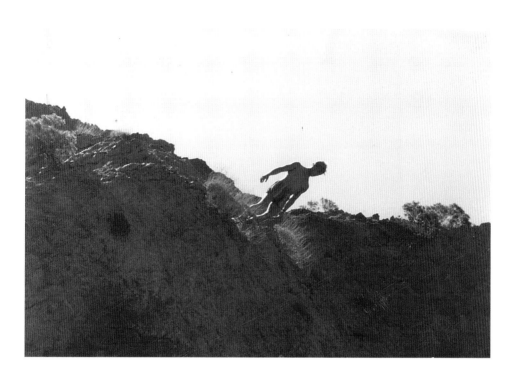

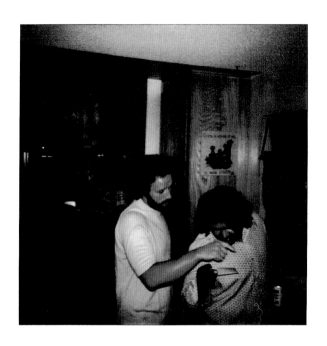

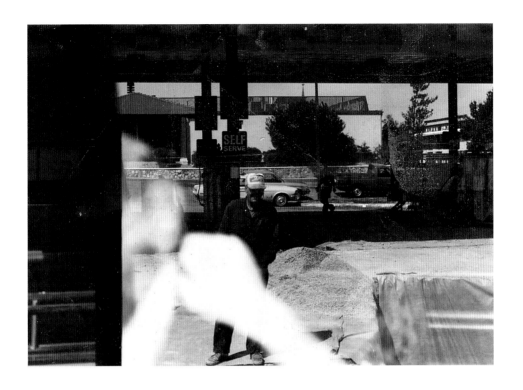

MY BELOVED ONES

HERE ARE THE SOUNDS
WE PROMISED YOU

MY HEART SMILES BECAUSE
THE MUSIC IS OUR CHRISTMAS
PRESENTS TO YOU

HEAR THE EXPERIENCES
OF ALL OUR LONG AND
PAINFUL LIVES

THIS IS OUR WAY TO TOUCH
ALL OF YOU FOR WHOM
WE LOVE SO MUCH
THIS IS HOW WE ARE
TWO PLACES AT ONCE

YOU ARE MY ONLY TRUE
FANS SO FEEL PROUD TO
SHARE IT WITH YOUR
LOVED ONES

SAY MY NAME BUT GIVE
THEM THE MUSIC
WELCOME TO
WE PRODUCTIONS

THE MUSIC IS MAGIC
IT HAS THE POWER TO:
HEAL COMFORT AWAKEN
AND MOVE YOU

THANK YOU MOM FOR
THOSE 3 WONDERFUL WORDS
FOR IT GAVE ME THE
STRENGTH TO COMPLETE
ALL OF THIS THAT YOU HEAR

NOW LISTEN TO THE
POWER OF WE

TURN DOWN THE LIGHTS
TURN UP THE MUSIC
THIS MUSIC SOUNDS
WONDERFUL IN DIM LIGHTS

MERRY CHRISTMAS 1991

V. LIDA JUNCTION–PAHRUMP, NEVADA

4:40 A.M.

-1- 6-26-92

Dear Tony,

You don't really deserve this letter but I'll write it anyway! I learned long ago, it's good therapy, to write down one's own feelings about things. It helps put them in perspective. (You might try it some time!)

You know, I could try & give you an ultimatum, like "me" or the "Vodka"!! But that's stupid. Only you can stop! There is, though, one thing I can do, and that is eliminate your "fist"!! DON'T EVER HIT ME AGAIN!! Don't even attempt it, not even "playing around"!!

Just to remind you what was said. The last 2 comments! Tony: I got you a nice place to stay!

over →

-2-

Estee: You're the one that caused me to need a place!

That's when you came up off your bed with fists flying, saying "This is a fucking better place than you had!"

You had no idea what was said or answered. You just drank too much & wanted to fight.

I will not go to the B&B anymore, and if you go, that will only tell me that, it, & the people there mean more to you than me!

You say you love me one minute & then you say you are trying to love me. Tony, I believe you don't know or won't face up to your feelings.

I accepted your apology because you gave me a chance

before! Boy, did I fall for
that one. Tony, I have to give
you credit, you're good!! You
didn't want your Mother to
see me gone or on the couch, so
you convinced me you were sorry!
 I honestly didn't want your
Mom to know, so I tried to
think of an excuse for my eye!
But, I'm going to let you tell
her. You come up with "the" ex-
cuse. When I'm asked for
verification, I'll simply say, "What
ever Tony says happened, that's
what happened." I will not
dispute what you say but I'll
not give any explanation. I don't
have to, we "both" know what
happened. If you can't admit it,
that's your problem! My prob-
lem is loving you so much

that I won't leave you! But, Tony, that love doesn't give you the right to strike me!

You're right, I said I'd stick by you, no matter what, don't test it again, because you said things, too. So far they were lies, all of them!

You said, you got me out of a bad situation with Buck! For what, Tony? So you could hold it over my head? As far as can see, I'm still there. One word from you ~ I'm on the street! But you say you care. We must define our words from two different dictionaries.

You seem to forget that I'm paying my own way here. I'm not freeloading. But I

also know or feel it is up to
you if I stay. One word from
you and I'm out. This is what
I have lived under, this fear,
for so long now. And you said
I wouldn't have to be scared any-
more! I'm only scared of you and
now more so than before.
Maybe that's why I'm so clumsy
around you! I try so hard to
please you and, basically, all
I want to do is, do for you!

Damn you, Tony, I love you
and if you can't accept it
then you deal with it! I'm not
asking for your love, I told you
that, but don't say it unless
you mean it. Don't say words
you think I want to hear!!

Darling, we <u>have</u> to <u>talk</u>!!
As much talk as we can.

You know, Tony, here we are living together and we know very little of each other. I don't mean past; I mean feelings; likes & dislikes, things like that. We are finding out, but only with surprise & arguments.

We keep the Gemini personality as a blueprint. This is wrong. Geminis are so complex, it takes almost a lifetime for them to know themselves. Then another lifetime to control and overcome it.

Right now you have the advantage! Your home, your Mom, your way of life with her. I'm the outsider! I'm only trying to fit in and have a home, too! I've mistakenly assumed this was what you wanted, too! Now, I know it's temporary, just like I'm

temporary. There is only one
thing I'm sure of in my life,
right now! That's my feelings,
and I shouldn't be condemned
for them. They may not be what
you want but I can't change
them! I love you, Tony! Why?
I don't know! It's not for your
money, you have none! It's not
for security, since your not
secure with yourself, even!
Plus, your whole attitude to-
wards life & others stink! So
what is it? I call it uncondi-
tional love. I love you as you
are! Most people see & know the
obnoxious, egoistical, self-righteous
asshole that you can be! But I
see into your heart, I feel I know
your inner, true self. The one
you hide, even from close

friends! That is why I don't
talk back a lot more than you
realize. Tony, you have no
concept, whatsoever, of how
much I bite my tongue & re-
main silent, even when given
the opportunity to speak up!
 Now, I know why, because I
know, or at least try to, how
you will react. What you see
as being contradictive, is not
what is meant. I'm honestly
just trying to talk to you in
any way I can. I don't know,
perhaps you were never app-
lauded or given credit for
your deeds as a boy, nor
your abilities. ~~Then~~, as an a-
dult, you accept no criticism, &
see and take, any sort of opinion
as opposition.

Darling, I'm not saying this is true, only trying to figure you out. This is because I *do* love you and want to please you; in order to do that ~~need~~ I have to know & understand you. If I didn't love you I wouldn't bother or care. But that is just the way *I* am. This isn't the only proof of love! Nor do I believe everyone should be this way. As I said this is only *my* feelings, not the absolute way of things for everybody!

As you can see, this is good therapy. It helps me come to terms with my negative feelings as well as positive. Don't get me wrong I'm still very hurt & angry, even a little confused about what, why,

and how the events of last night happened. One thing for sure, the "heavy" drinking should stop! I will but if you don't or can't then just don't be surprised at my early bedtime.

"What this comes down to is "communication"! Perhaps if I were able to say these things out loud & to you, also with you responding (this sounds like a definition for "conversation") last night would not have happened!

Honey, I really believe "we" (as in us) can work. But both of us have to ~~try~~ want it & try real hard! Just remember if it's too hard to speak out loud, write it down, no

matter how sporadic. I chose
letter form, but there are
other forms, like just a list
of your thoughts & feelings.
I want this, & I'll try & do
my part so it's up to you!

Eternally
Estep

P.S. Only a suggestion!
First topic of discussion:
Black eyes outside of boxing ring!

8:05 A.M.
6-26-92

Well,

I'm back! It's been a whole hour and ten minutes since I closed the last entry!

Boy, was that a laugh!! Three + ½ hrs of guts + emotions!! Of course, that's me, (FORMULA)

Love + Understanding = Slut!!

At least it's Fucking Slut!!

Well, I wanted communication! In a way, a radio through the air is a sort of ironic media!! At least, it wasn't aimed at me better yet, it wasn't me sailing the air waves. I guess that's considered self-control on your part!

Do me one favor, aim your fist on my right cheek + eye, that way, they will match!! Also, if you do, make it good

this time! You may not want
me getting up)!! You'll want to
make sure you knock me down,
this time, & keep me down

2:45 P.M.
6-26-92

My Darling,

First of all, I've got to get something cleared up. You made a comment on the phone about me being a Gemini Bitch this morning + walking out of the room! Number one, (FACE or HEAD) I still hurt from the night before! Number two, you had called me a fucking slut! Number three, + most important, Tony, you have yet to see me as a true "Gemini Bitch"! Believe me, you wouldn't survive, meaning, it would probably be the end of us!!

You say that I aggravate + egg you on to act the way you do! Well, keep treating me like a God Damn whore from one of your "books" and you'll get the honors of meeting a "TRUE GEMINI BITCH"! Only five people have had

over →

this bestowed on them! My father, my daughter (eldest), two girlfriends & one ex-boyfriend! The reason I bring this up is because, during this letter you may experience a small "bit" of that side of me!

Tony, I'm going to try and explain my feelings about sex and you!

This particular human function has never been at the top of my list of fun activities. I encountered it with as much enthusiasm as a root canal or monthly period! Something that had to be done, preferably, as quick as possible! I've never lied to you, whether you believe this or not. My ex was the first to make me climax! I was 37 yrs old!! Yes, married twice & 5 children & 4 miscarriages! I had some idea what I was missing but I was never guided with tenderness & understanding!!

After a year & ½ he stopped

making love to me! It was always
for him. Eventually, I began feeling
like a tool or something.

Then you came into my life!
You opened doors for me that
were sealed shut from all the hurt
and anger I felt! When you touch
me I shiver! My body tingles with
each caress! I only wish it were
more often!! It would be nice if
you came to me!

Tony, this is really difficult
for me to say. I'm afraid you
will take it wrong! I have to
ask you, though. Why don't
you cum very often?

Estée

I do Love and I do want to
change for the Better I Need
you

Love

P.S I owe you $20:00

Estice,

I Love you
theres A pork
chop iN the Ice
Box for you.
" EAT."

Love you

P.S its Cooked

Estee —

Yes, I will be out the 29th. Pay backs are a bitch for coming in my work (print) causing shit again. Lets see how you like it.

Diane

HOW TO SET A TABLE.

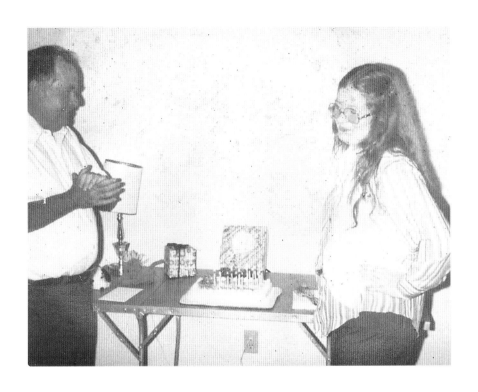

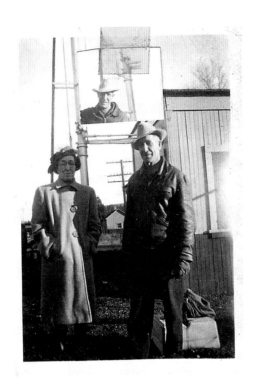

Wet shirty Sock

1 800-556-5157

242 102 8228
 71704
 1885 7.991

Cool Aid

Real Lemmon
Smokes

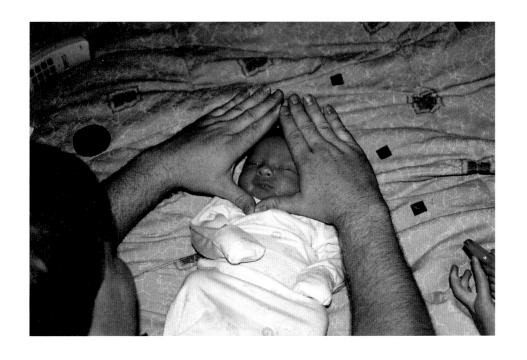

 6:20 P.M.
 4/17/96, Wed.

 Is this a dream or can this be happening to me? A
sweet female voice was calling my first name and I opened
my back door to find two pistols pointed at me and terse,
loud voices commanding me to place my hands behind my head!
I stumbled down the back steps trying to comply with the re-
peated shouts about where to place my hands. (I have had an
injury on a public bus in L. A. at 7th and Grand that makes
it very hard for me to negotiate steps, especially down!)

I was rudely handcuffed and placed in the back of the police
car. The lady officer drove my to Beatty. The right hand-
cuff was very tight and pained my greatly all the way. She
commanded me to get out and this I could not do as the leg
room was too tight for me with my injury to move! She shouted,
"I am not going to play your games!" The male officer drove up
and they bounced my ass on the ground and the man placed some-
thing around my chest, back and upper arms and literally lifted
me up, striking my head on the car.

They then dragged my into the building and shouted at me
questions which I did not answer! When T was uncuffed blood
was on my wrist back of the knuckle - the lady officer blotted
the blood with a tissue. I was then dragged to the jail cell.
I lost one of my house slippers and the male officer said,
"Throw him in with just his socks!" I finally saw my other
slipper under the bunk Monday morning.

I was told on Saturday afternoon that the Judge has said I
could go home after booking, with no bail, on my own recog-
nizance. I had noticed a blob of dried blood on the palm of
my left hand and knew this omen told me not to leave until
so directed! I was told fifteen times until Monday morning
that I could leave any time. I was offered food and coffee
twice per day, which I did not touch as I am a vegetarian
and have been for sixty years and I do not drink coffee or
any stimulant whatsoever and have not my whole life - I had
seen what drinking and smoking did to my brothers and one
sister. One male officer said I could drink water from the
toilet. I was offered cool water by a lady's voice several
times. I did not partake of anything until I was driven home
by a courteous officer!

I wrote a note to the Judge asking for my notice on court
appearance and that I would need transportation to same. The
next court appearance is May 15, '96, 10:00 A.M.

 -1-

The following is to better acquaint the Court with me
and all leading up to the present.

The charges by dead Mr. Creech are false - the documents,
statements or whatever are all false. The other judgment
against me in the same Court is false and as to the women
involved in this case, I know for a fact that Creech's wife
would be beaten in case did not stand by his and other false
testimony! She has been beaten nine times that I know of by
Creech and one I remember distinctly was when she would not
be a party to swapping wives. I saw his wife and we talked
about the incident as I knew all parties concerned.

Creech also made improper advances toward one of my ex-wives
as she will so testify! He insulted his wife constantly and
I have been in his home and heard him do same; he also cursed
her in case she did not do the work of two men on his ranch!
She has called me many times to come to Creech's ranch to
start the wheels for irrigating the alfalfa and it would re-
quire myself and two of my boys to do same. I have seen her
many times lifting 100 lb. bales of hay with hay hooks, load-
ing and unloading that a strong man would barely handle!

It just took one dumb know-it-all deputy to rob Irma Creech
of her rightful and just inheritance! It just took one dumb
deputy to get me kicked off the property that I now live on
plus one dumb, slick attorney plus one dumb school teacher
to have my place robbed and plundered. I will some day go
into detail. Even the stealing of my daughter's clothes
and granddaughter' special drapes from her bedroom windows!
This slick attorney was featured in the book about the "Nye
County Brothel Wars"! I have met the niece of one of the
deputies featured in that trial held in Las Vegas. She can
burn your ears.

Also as I have stated before in a letter, twenty-five people
are buried in a Government dump near Beatty and not twenty
five sheep as stated by the authorities. I know the man that
helped remove some twenty five physical bodies and "borrowed"
a cement mixer from this contaminated area and layed three
cement foundations in Beatty and two had to be jack hammered
up and hauled to this Government depository!

I also reported the theft of a large generator that was on
its way to the test site. I met with Government authorities
in Las Vegas. I have heard nothing about this. I know the
people that assisted in the theft and witnesses to same!

Another thing that might interest you as to my character, I
wrote to our President in 1988 and suggested that the scientists
investigate the free energy that permeates this whole universe
in the form of electrons which pulsate three times literally
at 3:00 o'clock and swing to 4, 5, 6, 7, 8 and 9:00 o'clock
and pulsate three times again, and now at 3:00 o'clock and
to 9:00 o'clock ad infinitum. Tesla understood this and
sent free electricity around the world with no wires, but
was stopped by Edison and the rich and greedy and even jailed!
Over a hundred years ago Keely was jailed also when he came
up with the harnessing of a mysterious perpetual power.

Back to my contacting the President - his speech writers then
had him in his speeches talking about each of us becoming a
point of Light and a song was even popular about this fact!
I submitted the same to NASA when over 40,000 submissions were
offered nationwide and of these 1,300 were accepted and mine
was one of them! I received a beautiful booklet about the
shot to Mars from the Vice-President and NASA.

In 1950 I was at a gathering in a mansion in which about
three hundred people were present when a lady wanted to talk
to me in private. We went back to the kitchen area and down
a semi-darkened hallway towards the servants' quarters. She
then said to me, "I was Alexander Hamilton!" I started to
place my right hand under the front of coat and say, "Yeah,
and I was Napoleon!" but before I could do this a shaft of
Light came down out of the ceiling to the floor about six

inches in diameter and she asked, "Did you see the Light?"

I said, "I did!" She then said, "That is to prove to you that I am telling you the Truth," then proceded to tell me who in the crowd of three hundred had been well known people of history, namely, George Washington, Benjamin Franklin, Benedict Arnold, his girl friend, also Joan of Arc and the man that had put her to the stake to burn, and also Aaron Burr.

I finally asked, "Why are you telling me these things?" as the shaft of Light continued to come down while she related the facts.

"You will be contesting with some of these people, and when you know who they really are you'll be able to handle them!" I wanted to know who I was and she said she was not permitted to tell me but that I would know in due time. It was seventeen years later when her prophecy was fulfilled! And the outcome is of court records and full transcript of this trial is on record for anyone's perusal. I avoided service on this suit for three years as I knew I would have to be the "bad guy" to upset the cart of all these goodies, so-called, especially the one that burned Joan of Arc - a big shot this time and also a big shot during and after the American Revolution from Britain - but just as crooked this time as in the past.

I have been brought in and interviewed by the City Attorney for Los Angeles who requested his secretary leave the room and off the record he said, "I have questioned hundreds of people and you are the only one I have ever thoroughly believed!"

I could tell you much more - last October and November I made a trip via AmTrack all around the United States and would volunteer to tell bed time stories to the handicapped in the lower car in which I usually rode. One fellow said many times, "That's a lie!" Another said, "I am a writer and publisher and I could make twenty million dollars with your stories and I don't care if they are lies!" The man that had said I was lying in a few days was one of my best friends! The crew would come in and listen and want me to go upstairs to other cars. You can only stretch so far!

I was in a restaurant on Figueroa Street in Los Angeles some years ago and as I arose to leave there were three people seated in a corner booth; the girl there said, "You have a Presence!" I scooted her over and joined them, saying "You said the right words!"

-4-

These three were USC students and one was in the film school there - one of the best in the country. He wanted to film me for a class project. I agreed in case he would do it impersonally and no one would know who I was. I dressed as the unknown comic and said things that blew his mind. He presented this as a class project and it bombed as what I said did not agree with science as understood by his professors.

Darwin is full of hot air. Freud has totally confused the scientific world. Einstein's theory only works in an atomic, three-dimensional world, and there are so many dimensions that our dense atomic brain could never grasp or understand the real potential of what real Life is all about. The big bang theory with asteroids whacking our planet is a pipe dream! I will say that even though Einstein worked covertly on the Manhattan Project and the Philadelphia Experiment, he did say, "God is not a magician - He is a scientist!" This makes sense!

I corresponded with Admiral Byrd and had the rights in writing from him to use his book Alone, and he flew into the interior of the earth but the Navy hushed it - as they did the Philadelphia Experiment.

We are so brainwashed by all forms of media that our brains are like a clogged-up chimney with black negative thoughts and feelings which have blinded our true understanding and we need a good chimney sweep to blast this nonsense out of our heads and let our hearts pulsate a flame up through our heads and coming to a point above the head just like a match flame and pulsate on up to our Higher Consciousness to literally lift us out of the mess we are in! It is not going to happen any other way and it is up to the individual as no one else can do it for you!

Then you as about two-thirds water and with about two-thirds ounces of silica in your body will become a walking, talking perfect computer without any electro-magnetic pollution affecting you. Also you will be shielding yourself from other out-of-whack computers sending their negative thoughts and feelings into the atmosphere and even permeating the earth itself. These ultimately express as storms and earthquakes to come back at us and destroy us when it reaches the saturation point!

I could paint you pictures of how we have been destroying our civilizations by the misuse of just our tetrahedrons. A tetrahedron is the most beautiful and exciting thing you ever thought of or visualized in its magnificent glory. I have made attempts at demonstrating it with a spark of the Secret of Life coming off the top of it connecting all other forms of vibration and Life throughout the whole Universe.

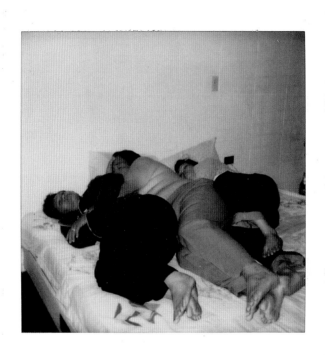

VI. EAST OF FALLON, NEVADA

Chapters

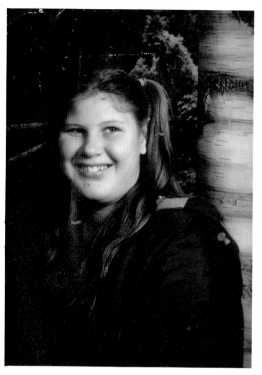
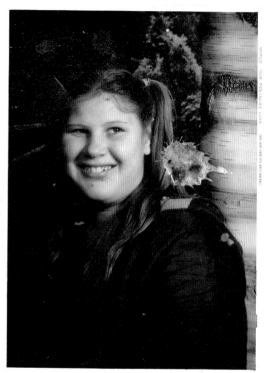

meeting at midnight

The gray sky and long black land
and the yellow half-moon large and low
and the startled little waves the leap
and fairy ringlets from the sleep
as gain the cover with Pushing prow
and quench its speed I the slushy sand
Then a mile of warm sea sented beach
three feilds to cross tell a farm appears
A trap at the pane Quick sharp
scratched and blue spurt of a lighted match
And a voice less loud though its joy and
tears Than the two heats beating each
to each.

Reapers

Black reapers with the sound of steal
On stones the Reapers are sharping their
scythes i see them place the hones
In there hip pockets as a thing thats
done and starts their silent swimming
one by one Black horses drive a mower
through the weeds and there a feild
rat startled squealing bleeds his belly
close to ground I see the blade
Blood stained and the continue cutting
weeds and the shade

(33)

In love with you ✓

I never really knew ~~you~~ him
~~he~~ ~~was~~ ~~you~~ just another friend
But when i got to know ~~him~~ him
I let my heart unbend
I couldn't help the past memories
that would only make me cry
I ~~couldn't~~ ~~forget~~ my frist love and ~~gave~~ tryed
ive love another try
So I've ~~tryed to fall~~ in love with you I will never let
rist love ~~it~~ go
I love ~~him~~ him more than anyone that I have
ever known
I'll never stop loving ~~him~~ him each and every day
my feelings for him will never change
So just know my feeling for him are
true
 Remember one thing
 Im still in love with him

TO. mother

I remember those days at the old house
The life where my life began
you would weed the small garden
of blue-starry forget me nots and violets
tending those delicate dahlias
you so loved
I played in the grass and in the sprinkler
running in and out of the Junipers
both of us building
me building forts and imaginary worlds
you building reality building the garden
building me

Drinkin Hard
Me
July 07

Fallon NV

Mom Kissing
Frog
Christmas
2006

Hell Storm
2007

Both Husbands
the ex and the now
July 07
Fallon Nv

missing familey

If tears could build

a stadir way of memories

I'd walk right up to

haven and bring you

home again

TRUth	DARE
Have you ever ate Some girl out?	Have You Ever Gave Anothe Guy A Blow Job?
	SAMeseXqUestion
Have You Ever Gave Some one a BlowJob?	Have you ever thought about having Sex with an animal?
Have You Ever kissed Somone of the same SEX?	Have you ever rimed anyone? rimming - liking someones butt hole
Have you ever fantized ubout fucking your Boyfriend with a strap on?	Have You Ever Had SEX With Your Sister/Brother?

Stairing into the mirror, Focus blurred, Coming undone
Faces stairing back at me, Screaming, Streaming
Rain falling, Trails in front of me, Totally insain
Bottle of pills, Self medicating, Face changing
Feeling of solitude, Becoming numb, Drainage
Misusing, Still abusing, Pacing, Thoughts racing
Hearing voices in my head, Telling me what to do
Feeling insain, Can't sleep

Page 6

[edit] | [delete]
The loneliest thing I know
As I sit recalling the past
A lost little girl all alone
Wishing for peace at last

A big smile and bright blue eyes
Was how my secret safely slept
I did good hiding the depression
Locked in my room while i wept

I was invisible to my mother
Lost because acquaintances weren't true friends
But the saddest thing I recall

Was wishing for the end

The loneliest thing I know
Used to be myself
And I probably wouldn't have made
If my friends hadn't helped

Page 11

Suicide July 15, 2007, 05:43:am

[edit] | [delete]
Life is never good for me and this is what I wish you'd see.
Just let me end it all for I'll be happy in the end, I'll finally be free.

Free from all the pain and torment and the never ending battle.
No more dealing with the arguments and tears, I'd finally be through with it all.

You just don't seem to understand that by keeping me here your making it worse.
If I were dead and gone by now I'd be happy, I wouldn't have this life, I wouldn't have the curse.

I'm already considering doing this even without your consent.
I know for sure that once its all over with my heart will finally be content.

So here I am just sitting there, on my bed with a knife to my wrist.
Please everyone don't be upset, please don't be pissed.

You just need to know I love you all but couldn't handle it anymore.

Page 12

A Poison tree

I was angry with my friend,
I told my wrath did end.
I was angry with my foe,
I told it not, my wrath did grow.

And I water it in fear,
night and morning with my tears,
and I sunned it with smiles,
and with soft deceitful wiles.

And it grew both day and night,
till it bore an apple bright.
And my foe beheld it shine,
and he knew that it was mine.

And into my garden stole,
when the night had veil'd the pole
In the morning glad I see
my foe out streched beneath the tree.

Liberty, curage, and since of Justice

73 chevy scottsdale 350 vs
4 wheel Drive fly wheel Broken or
Cracked

yea me & steven like you in
that outfit you were teasing
us the night we listened to
music

Lol sucks for you! Lol

yea I know but me and
him have you already rite

yeah well still thinking about 3
tha 3some!

Yeah I know it will be good if
or when it will happen

Yeah maybe huh!
yea I think it will bee good
its been 3 yrs since the last
time I had one

haha!

They are very intresting and
some time addicting oh 1 more thing
Steven said when and IS we do it
we have to write a agorement we dont do
thing unless hes present and he dont
if im not around floiowed with a prike
and a spot of blood on the papper Is we
ever do it and like it

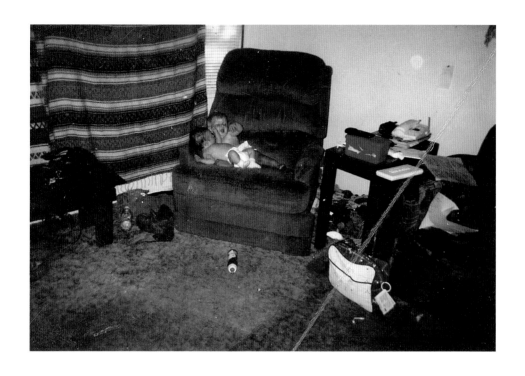

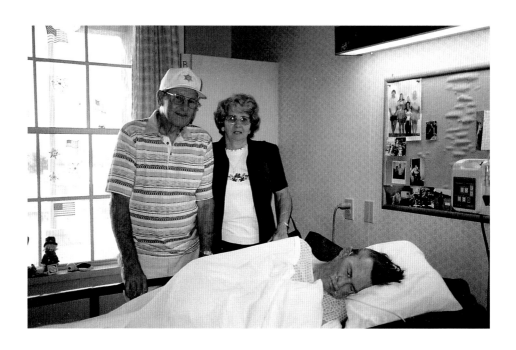

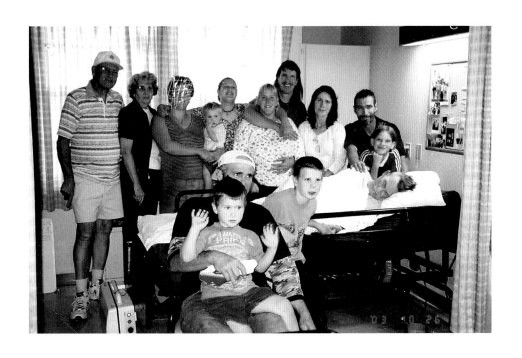

147

familey comes Before Boyfriend
So why dose it not Feel like it
why dose she think he is everything
he is a pice of shit Basterd and why
do I get stuk with them right
now I fucking hurt she has always
been there he comes along and
ruins it BASterd I say I hate
him she hanys out with him
mabe. I should hang out with
crystal she would be so mad
yea to bad steven ~~steven~~ will
not go over thure much

In fear of you

~~[crossed out text]~~

The pain of loving you
Is almost more then I can bare.

I walk in fear of you
The darkness starts up where
you stand and the nights comes thorough
your eyes when you look at me.

Ah neve before did I see
The shadows that live in the sun.

Wow every tall glade tree
Turns round its back to the sun
And looks down on the ground to see
The shadow it used to shun.

At the foot of each glowing thing
A night lies looking up.

Oh and I want to sing
And dance but I cant lift up
my eyes from the shadows dark
They lie split round a cup

January 16, 2007

Maryann,

How are you doing? I am doing fine. I just wanted to tell you sorry for ever making you mad at me. I miss hanging out with you. So what are you learning in school? I wish I was still in school. I am going to try to get a job soon. What do you want to do after you get out of high school? I wanted to go study for Child Care but I don't know now what I want to do. If marriage counseling don't work out then I just have to forget how I feel about him and just tell him to leave. I know it is going to be hard to do, but I don't need his stuff if I want a baby. The stress that he puts me thru I wouldn't be able to carry it, I would lose it with all the stress of him yelling at me and I wouldn't want a baby around him with his temper. What do you think about that? I really want to have a baby. So are you happy now that you are back with Tony? Have you ask him about coming out here? I can't wait to see you guys. Give every body a hug for me. Also give yourself a hug for me. So what have you guys been doing for fun? Where do you get the courage to tell a guy to leave when you tell him to leave and you start to cry or he does? May be it would be better on me if I knew I had some one waiting for me? But the only thing is that I told my self that it is wrong to go straight to a guy when you just told one to leave; but I have done it before. What do you think? That is if I could find one. But maybe if I lose this weight I could find some one like I am trying to do. Well I will let you go for now but not for long.

P.S write back soon. Your friend Joa

Gary and Rebecca is having a girl.

I miss you Sissy

I Love you a
and 6 of me I
Plz and sice

Since I'll
your miss
not, you
here for ever

Darkness lies within

Theres someting evel that takes hold upon my heart
That lies and tares me apart
I'm full with guilt
Which are made up of mystries and stories its built

My heart is satian of sin
Which glded with hate within
I wish there was apart of me I can delete
Because Im not fully complete

Theres an evil and dark passion of my soul
That keeps me from being whole
And if someone had done me wrong
I will let him or her suffer long

Because to me – it matters not
This is one thing that should not be ~~forget~~
forgotten

Alone with out you ✓

Sitting here without you
kills me more than smoking
oh How I miss you so
But hate you so
I wish you was here
But Dead in a dich
oh How I miss you so
I miss them nights when your
with me hugging and holding
so close to your side
Oh how I miss you so
But wish you were dead in a ditch

AFTERWORD

Mark Levine

You have just read a work of literature.

Lost and isn't simply that, surely — it isn't any simple, categorizable thing. Part archaeology, part scrapbook, part catalog of the modes and manners of representation available to subjects of postmodern American struggle, this work documents a journey through an underworld that adjoins our own familiar, ordered world, with which it comes to bear unnerving affinities. The book's materials are brutally, literally, real, and the austerity of its means rejects alteration or fabrication. Yet it is, I think, work of uncanny imaginative daring and force, and work of uncompromising originality.

Originality? With the exception of a two-sentence-long preface, nothing in *Lost and* was "written" in the usual sense by its author, Jeff Griffin, whose rigorous absence from the text is the flip side of the book's insistent inclusion of a population of people who might seem, otherwise, to have vanished altogether from cultural memory. For Griffin, the acts of searching for, gathering, processing, and preserving the book's texts — what one might, in a more conventional literary context, describe as acts of discovery — are neither passive nor polemical, but bear the marks of strenuous, self-implicating devotion rooted in personal circumstance and sensibility. It seems to me that Griffin has come upon his own form of writing, an invention grounded in artistic precedent, accident, intuition, and need.

Griffin was raised in Reno, Nevada, the only child of working-class parents. The family frequently ventured to the desert, seeking a remove from other people and from the constraints of everyday life. In the Great Basin of northern Nevada, Griffin and his parents would explore the remnants of derelict mining camps and ghost towns, and search for Native American artifacts. Deeply attached to his uncle, Ron Griffin, a Los Angeles-based artist whose paintings painstakingly incorporate images and documents he finds in and around abandoned desert settlements, Griffin enrolled in college as an aspiring sculptor. While working on a wooden sculpture, he injured his hand on the blades of a wood planer. He lost parts of two fingers and endured multiple surgeries and a long period of rehabilitation to regain function. During that time he turned his attention to writing and working with texts, but it was a few years later, while attending graduate school at Art Center College of Design in Pasadena, that Griffin realized he had lost his interest in sculpture. He also strongly disliked Southern California, where, strapped for money, he was living in his windowless studio. He would step outside for a break, stare at mountains to the east and imagine the Mojave Desert on the other side. At

every opportunity, he began to pack provisions and head off to the desert for days at a time. He would turn onto unmarked back roads and sleep in his truck. He was drawn to the areas beyond the edges of towns, far from shops, schools, and churches, where he would find sparse, makeshift settlements—campers and trailers and improvised structures, standing alone or in clusters, attended, at times, by emaciated dogs and horses.

These outposts appeared to have been abandoned as hastily as they had been established. Trash was everywhere—scattered downwind and left to deteriorate in the desert climate, as well as blanketing the interiors of residences. Some of it had been there for decades. Griffin took to scouring through the debris. The effort was neither easy nor safe. Trailers were infested with pigeons and rodents, and hantavirus, transmitted by contact with deer mice droppings and urine, posed a serious risk. Temperatures could reach 120 degrees. The desert remained a place of refuge for all manner of people who protected their isolation, including those involved in the manufacture of methamphetamine; Griffin carried a weapon with him on his outings. Most of the material he found was mundane—bills, magazines, junk mail, household garbage—but some of it was harrowing, poignant, and enigmatic, and he would haul loads of it to his parents' garage. He did not consider that he was gathering texts for a book. It was only after some years of living among piles of this reclaimed refuse that Griffin fashioned his response to it: A meditation on loneliness, yearning, persistence, and disappearance that bespeaks precise authorial discernment and yields an experience approaching the visionary.

For Griffin, the process of finding is itself a crucial aspect of the writing—the physical and emotional syntax, as it were, out of which the particular vocabulary, texture, and formal operations of the work arise. The book's conceptual leap, its inextricable marriage of the author's arduous acts of excavation to the desires explored in the materials themselves, is

as elegant and artful as to strike the reader with the force of inevitability. The astonishments of *Lost and* are available from its opening pages, which comprise Griffin's transcription of a notebook charting the development of a budgie's lexicon. For Griffin, this is an act of faithful copying, one whose content itself records an initiation into language as mimicry. It might be going too far to suggest that copying, for Griffin, involves the effort to receive instruction in the symbolic idioms of otherness; still, his readiness to offer himself as the bearer of lost desert voices comes across less as a gesture of appropriation than as one of extreme submission. It is the predicate of Griffin's brand of spiritual questing, of losing oneself in the service of self-discovery. "The following work I found discarded," he notes in his preface, putting the work before the self, and yoking, as the book does in myriad ways, the condition of being found to that of being discarded.

I would distinguish Griffin's efforts from familiar and seemingly related practices of "found" artistic production, particularly collage, whose effects are generated by re-contextualization—the kinds of forced juxtapositions that aim to produce surprising, ironic, aesthetically pleasing, and sometimes pedantic associations. This method is absent from Griffin's handling of his materials, which is resolutely transparent. His texts are neither transformed nor presented as mere documents. Instead, they arrive at something like a language through which regions of emotional extremity and difference might be accessed. Each chapter's texts belong together by dint of geography, and are organized, I think, in ways that provide a continual deepening of a reader's immersive journey. This arrangement, though, resists narrative elaboration and refuses editorial commentary. A reader has to encounter the book's texts in the full dimensions of their mysteriousness, a realm in which one is left to wonder but cannot pretend to know.

Griffin's work invites the reader to assume the position that the au-

thor, himself, occupies. We engage the texts in a manner analagous, but not identical, to Griffin's acts of finding, and are compelled to enter the work without the privilege of analytical distance. The transcribed texts in the early pages quickly give way to mechanical reproductions, as though Griffin sought a stricter version of reality and immediacy. *Lost and* demands respect for the dignity and indignities of its found items—stained, torn, bearing marks of the abuses of time, the elements, and human response. The variety and tonal range of these documents is both a delight and a testament to the expressive ingenuity and need of their anonymous authors, whose voices, often startlingly distinct, participate in the book's collective act of composition. Charts, questionnaires, lists, compulsively detailed letters and journal entries, legal documents, jottings, astonishingly vivid photographs—these are the forms in which lost people inscribe their psychic, sexual, religious, economic, and social yearnings.

Then, too, there are poems. Whatever assumptions one might make about poetry being reserved for occasions of refined detachment, the poems here offer an alternative: Poetry as an anthropological necessity, a means of embodying urgent impulse through ritualized pattern-building and pattern-breaking, through borrowing and relinquishing. *Lost and* makes no claim for the literary value of the poems it includes, but rather offers a reminder that the elemental desire to turn to poetry precedes and annuls matters of literariness. (Griffin's inclusion of a single canonical work—a handwritten copy of Blake's "The Poison Tree"—only reinforces the irrelevance of distinctions between the literary and the non-literary.) Poetry here is restored to the human hand, which grasps after desire in ways particular and universal, and raises a challenge to the ideologies that enforce separation between our world and that of desert dwellers, between abundance and impoverishment, finding and losing. Those are the boundaries this book crosses.

There is no "outside" in the world of *Lost and*—no exterior photos of the trailers in which the work is found, no secure remove from which to judge, mock, or sentimentalize those to whose words and lives the book provides intimate access. Intimacy is an act of self-relinquishment and willing trespass, and whatever sensations of voyeuristic pleasure the work might afford are anxious and fleeting. This is not an experience of sightseeing; it permits, and demands, an identification with the humanity of the people it discovers on its journey into the desert, and a discovery of the otherness of oneself. In the audacity and difficulty of its reach, *Lost and* extends the traditional work of poetry. Like all instances of imaginative transport, this book is the finding and shaping of what had existed all along in the wilderness of the inexpressible.

KUHL HOUSE POETS

Christopher Bolin
Ascension Theory

Oni Buchanan
Must a Violence

Michele Glazer
On Tact, & the Made Up World

David Micah Greenberg
Planned Solstice

Jeff Griffin
Lost and

John Isles
Ark

John Isles
Inverse Sky

Bin Ramke
Airs, Waters, Places

Bin Ramke
Matter

Michelle Robinson
The Life of a Hunter

Robyn Schiff
Revolver

Robyn Schiff
Worth

Rod Smith
Deed

Cole Swensen
The Book of a Hundred Hands

Cole Swensen
Such Rich Hour

Tony Tost
Complex Sleep

Susan Wheeler
Meme

Emily Wilson
The Keep